How to Hear
the
Voice of God

T0148312

Ernest J. Murat

HOW TO HEAR THE VOICE OF GOD

iUniverse books may be ordered through booksellers or by contacting:

iUniverse
1663 Liberty Drive
Bloomington, IN 47403
www.iuniverse.com
1-800-Authors (1-800-288-4677)

ISBN: 978-1-4917-5922-6 (sc)
ISBN: 978-1-4917-5923-3 (e)

Library of Congress Control Number: 2015901426

Print information available on the last page.

iUniverse rev. date: 02/23/2015

Contents

How to Hear
the
Voice of God

Acknowledgments

Special thanks are due to Pastor Shirley Ezell-Fennell and the Greater First Church of Deliverance family; my good friend Pastor Barry Williams; Pastors Stan Moore, both junior and senior; Pastor Teresa Moore; and Pastor Gerri Moore and the entire Words of Life Fellowship Church. I also want to thank brother Leo and sister Annie.

A great shout-out to the love of my life, my wife, Jeanne Murat. I love you, sweetie, and thank you for all your love and support. I could not have done this without you. Thank you for believing in me.

Introduction

God has been talking to me about this book for five to six years. His message had been in my spirit for a long time; finally, I gave in and decided to submit to the Holy Spirit. I encourage you to submit to the Holy Spirit; whatever He wants you to do, just do it.

This message will have a powerful impact on your life, family, and business. Allow God to minister to your spirit and do what He wants to do in you. Many believers still have a hard time believing that God still speaks to people on Earth.

Yes, God still speaks, and He does not want to hide His plan and purpose from us. When He speaks, it is both exciting and scary, but He always has our best interests at heart. This truth will help us seek Him out even more. What God wants to do in our lives is beyond our thoughts, dreams, and even our imaginations.

The more you seek Him, the more likely you are to hear His voice. I encourage you to seek out God; it is okay to desire to hear His voice. When God speaks to you, it is a

marvelous thing, a life-changing experience. It is even better when you listen to and obey Him; do whatever He tells you to do. It is one thing to hear and a whole different matter when you listen.

God said, in His Word in 1 Samuel 15:22, that obedience is better than sacrifice. When we hear His voice, the next thing that should happen is obedience.

Jesus clearly states in John 10:27, "My sheep hear My voice, and I know them, and they follow Me."

The result of obedience is blessing. Enter into God's rest and experience what He has in store for us. When one has both favor with God and with men, then one can enter into His rest.

Chapter 1

How to Hear the Voice of God

Then God said, "Let us make man in Our image, according to Our likeness; let them have dominion over the fish of the sea, over the birds of the air, and over the cattle, over all the earth and over all creeping thing that creep on the earth …"

Then God blessed them, and God said to them, "Be fruitful and multiply; fill the earth and subdue it; have dominion over the fish of the sea, over the birds of the air, and over every living thing that moves on the earth." (Genesis 1:26, 28 NKJV)

From the beginning, God has spoken to us. He is always saying things to us, about us, and for us. We don't always comprehend the meaning behind His words. However, the more time we spend with Him, the more we know what He says to us is true.

The word *hear* comes from an Old English word, *heren*, which means to be on guard, to perceive, apprehend by the ear, to have the capacity to understand sound. Every person needs to have the ability to hear. It is a precious thing that God has given us.

We should be able to hear two different sounds. One comes from the natural state of our minds. The other we should hear as believers is the supernatural, spiritual sound. I will discuss each of these topics in greater detail in later chapters.

It is important for every person, but particularly believers, to hear the voice of God. Why? It will determine whether you are successful. It will determine whether you do what God calls you to do or what you want to do. It will determine your plan and purpose in life.

It will make a difference. Listening to God will change your life in a major way. Hearing His voice is exciting and exuberating, but it also can be overwhelming and scary. But God always has your best interests at heart. You can trust Him. People often ask, "What does He sound like?" He sounds like you. Whatever you sound like, that's who God sounds like. If you have an accent, so does He.

God speaks to us and through us, using various means. He uses different avenues and circumstances to get His message across. He speaks through signs and wonders. There are no language barriers. He can speak through nature. He is the Almighty. He is the master architecture of heaven and earth.

How Does He Speak?

One of the many ways God speaks to us is through our consciences. His is an inaudible voice. You will hear only your own voice. For example, you may have the desire to call someone you haven't talked to in years. All of a sudden you feel a need to talk to him or her, and when you do, you realize the person is dealing with a difficult situation and needs to talk to someone. God is using you to stop a tragedy that might have taken place had you not talked to your friend.

Some people call it a hunch or a coincidence, but I have had too many encounters to describe it that way. No, it actually is God speaking to you, your conscience, or your spirit man.

For example, one morning, I was driving to work on my usual route. In my spirit, I heard a voice say, "Don't take this route today. Take Ali Baba Street and go through the city of Opa-Locka." In those days, I was not as accustomed to hearing God's voice as I am today. It did not mean, however, that God was not talking to me. As I found out later, God had always talked to me, but I had not listened. I did not know Him well enough to recognize His voice. I had not spent enough quality time with Him and in His Word to know how caring and loving He truly is.

Most people who live in that region of South Florida know that Ali Baba Street in Opa-Locka is not the safest place. Therefore, there was a struggle in my spirit regarding whether or not I should take that route. Then I heard very

clearly again: "Do not take this route to work today. Take Ali Baba Street through the city of Opa-Locka."

I eventually listened and took Ali Baba Street rather than my usual route. About fifteen minutes after I got to work, I heard the news: an eighteen-wheel trailer truck had flipped over just at the time I was supposed to be on that road. Traffic was backed up for several hours. God had saved my life as He always does. God spoke to my spirit man and because I listened, I was saved from what could have been a terrible accident. Thank You, Lord.

Chapter 2

What Is a Spirit Man?

God communicates with you through your spirit man. If your spirit man is open to receive God, He will use you for His glory and purpose. As stated in 1 Thessalonians 5:23:

> And the very God of peace sanctify you wholly; and I pray God your whole spirit and soul and body be preserved blameless unto the coming of our Lord Jesus Christ. (NKJV)

> And may the God of peace Himself sanctify you through and through [separate you from profane things, make you pure and wholly consecrated to God]; and may your spirit and soul and body be preserved sound and complete [and found] blameless at the coming of our Lord Jesus Christ [the Messiah]. (AMP)

This scripture tell us that each of us has a spirit, a soul, and a body. Each of us is a three-part being just like our Heavenly Father. We were made in the image of the Trinity: God the Father, the Son, and the Holy Spirit. When you experience salvation or are born again, that is when your spirit man comes alive. You can truly understand and discern the things of the supernatural.

Your spirit man communicates with God, and the Spirit of God communicates with your human spirit. It is a Spirit-to-spirit communication. For example, when Mary was carrying the baby Jesus, she met with Elizabeth, who was also pregnant, with John the Baptist. "And it happened, when Elizabeth heard the greeting of Mary, that the baby leaped in her womb; and Elizabeth was filled with the Holy Spirit. She spoke out loud, 'Blessed are you among women, and blessed is the fruit of your womb'" (Luke 1:41–42 NKJV).

Your spirit man has to be open in order for you to receive all the blessings God has for you. God's ultimate desire is to bless you. He wants the best for you. He has your best interests at heart. He is not trying to keep anything away from you. But there is work that you have to do and that is to open yourself to Him. Submit yourself to Him. Give Him access, so that He may do His work in you.

Our spirit men work when we open ourselves to God. Submitting ourselves to Him will work to our advantage. "Therefore humble yourselves under the mighty hand of God, that He may exalt you in due time, casting all your cares upon Him for He cares for you" (1 Peter 5:6 KJV).

Chapter 3

Experience Salvation by His Voice

What Is Salvation?

Salvation occurs when one experiences or receives Jesus Christ as his or her Lord and Savior. It is like moving from darkness into light. God speaks loudly about salvation, because there are lot of things He desires to do for you. But unless you give your life to Him, He will not have total access to you.

Will you consider giving Him total control today? You'll be glad you did. He has rescued us from dominion of darkness and transferred us to the kingdom of His beloved son. Giving Him control will help you understand this book and, most important, it will improve your relationship with the Almighty God. "Therefore, if anyone is in Christ, he is a new creation; old things have passed away; behold, all things have become new" (2 Corinthians 5:17 KJV). When you are in Christ or a follower of Christ, you are a new creature.

What exactly does that mean? It means that you will view your life differently when you are a son or daughter of Christ. Your spirit man will come alive. You will become aware of certain things that you didn't notice before. God amplifies your understanding. He develops you as a human being. He enhances your ability to discern. You will be more sensitive to people's needs. If you have not yet become a child of Christ, take a moment and do so. It is very simple. Repeat after me, and pray:

> Lord Jesus, come into my heart. I acknowledge that You are the son of the living God. You sent Your son to die for my sin. I acknowledge that I am a sinner, and I need You to forgive my sins. Come into my heart and be my Lord and Savior. Fill me with Your Holy Spirit and change my life around in Jesus's name. Amen.

When you say this prayer for the first time and mean it in your heart, you will be saved. You will authorize God to work on your behalf, and your spirit man will be open and ready to receive messages from the ultimate commander-in-chief. I encourage you to read your Bible on a daily basis and to find a good Bible-focused church. Your ears are ready to receive and obey His voice.

Hearing God's voice is a crucial part of your new Christian lifestyle. It is be important to know where God will take you. It will be the best thing that will happen to you— giving your life to the Lord.

Above, I spoke about the two parts of hearing. The first part was natural (physical) hearing, and the second was spiritual hearing. We now will concentrate on hearing in the spiritual realm. It means you can see and hear what most people cannot.

Once you are saved, your spiritual hearing will open. You will be anointed by God, which will make you totally dependent on Him. You will be able to hear naturally as well as spiritually. Your spirit man will be alive. You will see and hear in the supernatural. This is God's gift to you.

You see, my brothers and sisters, God often speaks to us. The problem is, much of the time we are not listening or paying attention to Him. Therefore, we often miss out on what He wants us to do. Make up your mind to never again miss anything God offers to you.

Before we can hear, we must be good listeners. Many people don't know how to listen. They know how to talk. They might even hear the words you utter. But they will still miss the message that comes from your mouth. We must know how to listen: "Wherefore, my beloved brethren, let every man be swift to hear, slow to speak, slow to wrath" (James 1:19 KJV).

The next step is to do what God has said. If you only hear and do not act, then something is wrong. Hearing must be followed by action. "But be ye doers of the word, and not hearers only, deceiving your own selves" (James 1:22 KJV).

We learn in the scriptures that hearing alone won't do it; we must also do. We will never reach the heights that God expects us to reach until we act upon His Word. Otherwise, we are just deceiving ourselves.

Many years ago when I served in the US Navy, I was taught as a new recruit in boot camp to pay attention to details. Even though I was not yet a believer, I had to pay attention to what the company commander's lessons, which remain instilled in me until this very day. Company commanders usually are ranked E-6 or above, which means these enlisted men have been in the service for a while. They have been there and done that. They are experienced individuals who know what recruits need to learn to do their jobs effectively and properly.

When a superior officer gives a command, you must repeat the command and say sir, as a sign of respect. Likewise, we must honor and respect God's words and commands when He gives us a task to accomplish. We must give honor where honor is due.

Imagine, for example, there is an exercise taking place on the USS *Washington*, an aircraft carrier in the Atlantic Ocean, fifty miles away from Guantanamo Bay, Cuba. Lieutenant Shocks is on the bridge, giving an order to the quartermaster, Petty Officer Third Class Mathew. Shock says, "Five degrees left rudder to station on course 525." Mathew responds, "Five degrees left rudder to station on course 525, sir."

When God speaks to you, you must respond and then act immediately. Notice that Petty Officer Mathew did not say, "*I will think* about turning five degrees left …" He acknowledged the lieutenant, and then he acted immediately, based on what he'd heard.

We serve the holiest commander-in-chief. He is the Prince of Peace and Lord of Lords. He issues commands based on agape—the unconditional love of God. He speaks to us on a daily basis about a variety of subjects and issues.

We must listen to what He says to us and use it to advance in life. God's ultimate desire is for us to advance. What is His plan, and how can we fulfill it? If we cannot hear what the true commander-in-chief says, then we are truly in trouble.

Chapter 4

Why Is He Speaking to Us?

God has a purpose when He speaks. His plan can be manifested on this earth. Each and every one of us is part of this great plan. We all—you and me included—have a part to play.

He has a message for each of us. He will tell us where to stand, what role we will play, and how we ought to play it so it will fit in the great scheme of things. All of it will work, because He alone sees the grand picture.

We must keep our ears attuned. We don't know God's entire plan, but we must obey and work together with Him to accomplish it. He can and will reveal His plan to us through His Spirit. The scriptures tell us, "Eye has not seen, nor ear heard, nor have entered into the heart of man the things which God has prepared for those who love Him. But God has revealed it to us through His Spirit. For the Spirit searches all things, yes, the deep things of God" (1 Corinthians 2:9–10 NKJV).

One night my wife, Jeanne, and I were moving from Virginia to Florida, our home state. We'd both come from broken homes, so we were determined to make our marriage work. On that night, we had a serious encounter with God. I will remember it for the rest of my life. Those days were very tough for us financially. We had only been married a year. I had just gotten out of the navy. My wife was the only one working, and she had a part-time job. We had an old Buick Grand Prix that we'd bought two weeks earlier. We could not pay for a little shack-like, one-bedroom apartment, whose rent was less than $400 a month. We were poorer than poor in those days. Both of us were saved, and we loved the Lord very much. At least we had one good thing going for us: we were serving the Lord, and we knew how to pray.

We got lost a few hours after we left the apartment. It was late at night, and we did not know where we were going. It was not very smart of us to take such a long drive so late at night, without being certain of the direction. We did not preplan at all. But as we continued to drive, it never occurred to us that what we were doing was not very smart.

We saw a gas station about a few miles down the road. I said, "We are going to stop there and ask for directions." But the gas station was closed. Just then, our car stopped running. We did not have a cell phone, GPS, or a map; there was no public phone. *What do we do now?* I thought. We did not know what to do … initially.

We did know how to contact the Heavenly Father. We began to pray in a spiritual language, that is, in tongues. When you don't know what to do, pray in the spirit, and God will

show you the way. We prayed for about ten minutes. I heard a voice say, "Open the hood of your car, lay your hand on the battery, and continue to pray in the spirit for another minute." I did exactly what the Lord told me to do.

After that, I put the key in the ignition switch and turned it. All I heard was "brooooommm …" The car sounded as if it had just been tuned. It sounded better than it had when we'd bought it, like we'd had the engine overhauled. We were very grateful to God. We praised Him all the way to our destination, Miami. Glory be to God.

We must submit to Him completely. Draw closer to Him every day. Seek His face on a daily basis and maintain a conversation with Him. This is what it takes for you to hear His voice continually. His voice is so refreshing, and a sweet aroma comes with it too. You get drawn to it: "The times of refreshing shall come from the presence of the Lord" (Acts 3:19 KJV).

God's voice and His ways of doing things will be second nature to you, if you choose to be close to Him. Find reasons to speak to Him, and maintain a heart filled with thanksgiving. That will bring His presence on the scene very quickly. We must know how to draw Him in. I would rather hear a direct word from God than a thousand sermons from any men or women of God. When you are in His presence, His voice will not be too far away, and He will whisper great things in your ear. What a great joy: "You will show me the path of life; in your presence is fullness of joy, at your right hand there are pleasure forevermore" (Psalm 16:11 NKJV).

Spending time with Him will allow you to hear Him. This is both profound and true. He will show you the path of life. He is waiting on you. As I said earlier, a heart filled with thanksgiving will manifest God's presence.

One day, I had just finished eating breakfast. A feeling of depression tried to capture my attention: *Oh no, there is no place for you here*, it said. All of the sudden, I thanked God for everything I could think of. I confessed the following, loudly, since I was the only person in the house that day: "Lord, I thank You for my sound mind. Thank You for giving me favor wherever I go. The glory of God shines upon me today." The presence of God filled that house like it never had before.

I heard a voice say to me, "Thank you, My son."

My response was, "Why are You thanking me? You are the one who did everything."

The Holy Spirit said to me, "No, My son, you chose to obey."

Needless to say, I was in awe. That is the message God is delivering to all of us: we have to choose to obey Him. We must hear and obey Him.

He is a great God. He is available twenty-four hours a day. His line is never busy. If you want to speak to Him, He will speak to you. Go ahead and issue the invitation; He will definitely show up. Why don't you thank Him right now? He is already here! He is the one you sense in your heart.

15

He wants to do great things through you. Why don't you allow Him to do so right now? Stop for a moment, and thank Him.

Do You Desire to Have Great Success?

A great way to achieve success is to listen to the voice of God. He will guide your everyday decisions in your life or your ministry. Learn how to listen to His voice and obey Him.

As Psalm 29:3–9 (NLT) tells us, the voice of the Lord is very important:

> The voice of the Lord echoes
> above the sea.
> The God of glory thunders.
> The Lord thunders over
> the mighty sea.
> The voice of the Lord is powerful;
> the voice of the Lord is full of majesty.
> The voice of the Lord splits
> the mighty cedars;
> the Lord shatters the
> Cedars of Lebanon.
> He makes Lebanon's mountains
> skip like a calf;
> and Mount Hermon to
> leap like a young bull.
> The voice of the Lord strikes
> with lightning bolts.

> The voice of the Lord makes
> the desert quake; the Lord
> shakes the deserts of Kadesh.
> The voice of the Lord twists mighty oaks
> and strip the forests bare.
> In His temple everyone shouts, "Glory!"

As Acts 10:1–30 describes, Cornelius was a man of prayer, and he loved to give. The Bible says that he was a devout and righteous man, and he feared and revered God. This man opened himself to blessings all the way around. He didn't know how to get God's attention, but because he gave to the poor, God came on the scene.

Men measure success based on how many sales were made, how many of this or that they have produced. God measures success according to how obedient you are. Are you willing to do what He says, regardless of how strange it may be? Let's look at this man, Cornelius. One afternoon, he had a vision. An angel of God came to him and said, "Cornelius."

And Cornelius answered, "What is it, Lord?"

The angel said, "Your prayers and gifts to the poor have come up as a memorial offering before God. You know what that means, son? I am about to embarrass you with a blessing."

Cornelius loved God. Cornelius was already a wealthy man. He did not need money or influence. He needed a greater relationship with God, as we all do. God sent His personal representative, Peter, who went to Cornelius's house and

began to minister. The power of God came down, and everyone was full of the Holy Ghost, just as the apostles were on the day of Pentecost. They were slain in the Spirit of God.

Everyone at Cornelius's house—including his relatives and close friends—was slain in the Spirit, under the power of God. Cornelius was a Gentile and Peter was Jew, but God told Peter not to be biased.

Cornelius was a man who hungered after God. He wanted to know and hear from God. When you do likewise, God will move heaven and earth on your behalf. He won't allow human traditions, thoughts, or ideas get in the way. You must be hungry to hear what God wants to do in your life. Therefore, your blessings are based on what you do. Isaiah 1:19 (AMP) says, "If you are you willing and obedient, then you shall eat the good of the land." The NIV version says, "You shall eat the best that the land has to offer."

Desire the best from God. He will not mind at all, but you also have to do your best. Put your best into whatever you do for God. Spend time with His Holy Word, seek His face, and wait on Him, and see what He has to say. He has something to say about every subject; however, we must involve Him. Don't make a mistake and do your own thing, and then, when it doesn't work out, go to seek God. It does not work that way. Seek God first. Put Him first, and everything will work out. It may not happen the way you want it to, but it will fit God's plan.

Chapter 5

God Uses Other People to Speak to You

God may use a complete stranger to speak to you. God may use someone who knows absolutely nothing about you. You may not have mentioned anything about yourself to anyone, yet God has someone reading your mail. He may use your situation to help someone else. Your circumstances are not new to God. God knows you better than you know yourself. Nothing you do is a secret to Him.

Perhaps you are wondering, *How does this person know so much about me?* God is speaking to him and through him about you. God did the same thing with the prophet Elisha:

> When the king of Syria was warring against Israel, after counseling with his servants, he said, in such and such a place shall be my camp.

> Then the man of God sent to the king of Israel, saying, Beware that you pass not such a place, for the Syrians are coming there.

> Then the king of Israel sent to the place of which (Prophet Elisha) told and warned him; and thus he protected and save himself there repeatedly. (2 Kings 6:8–10 AMP)

God used Elisha to tell the king of Israel where the plot against him would take place. God revealed the enemy's plans to the prophet, and the king of Israel was able to disrupt the plot.

Go a little further in 2 Kings, chapter 6, to verse twelve. The king of Syria thought there was spy on his own team. One of his servants said, "No, sir, there is no spy among us. A prophet in Israel is able to hear what you are saying in your bedroom, and he is relating that information to the king of Israel" (author's paraphrase).

Would you like to know what will be discussed in the boardroom before the meeting takes place? This is the kind of connection we have with God. We have a supernatural spy working on our behalf. We know what the enemy is doing ahead of time. The only thing that God asks of us is to be in tune with Him.

"He will tell you things to come" (John 16:13 NKJV). God will let you know what is coming before it comes to you. He can speak the end at the beginning. When you have a special

relationship with Him, He will watch out for you and keep you safe. He is the kind of person we need on our side.

How is God able to use a complete stranger to hear what's happening in your life? You have to be familiar with His voice. He loves us, and we are the apple of His eye. "My sheep hear my voice, and I know them, and they follow me" (John 10:27 NKJV).

We are His sheep. He knows us. He knows us better than we know ourselves. He wants the best for us. We should be able to recognize Him, regardless of where we are. We should be able to detect His voice. It is just like a parent. Her child could be among a thousand kids, making noise. She will know the difference between her kid's voice and the voice of another child. Why? Parents can recognize their children's voices, even if their offspring are among lots of people. In the same way, get to know God's voice and know His ways. Psalm 103:7 (KJV) tells us that God made known His ways to Moses; the children of Israel only knew His acts.

It is vitally important that we know God's ways. We should know what turns God on and what turns Him off. He can speak to us clearly, and nothing is off limits for you.

People who know God's ways are people who seek and worship Him. They constantly seek out God. He is not satisfied with the status quo; He wants you to go deeper. "Deep calleth unto deep at the noise of your waterspouts: all your waves and your billows are gone over me" (Psalm 42:7 KJV). The deeper you go with God, the easier it is to hear His voice.

When you seek only His hand, you are looking for limited provisions. You are looking only for a handout. My God is good. He does not want His children to seek Him only for what they can get from Him, for what He can do for them now. A person who seeks God's hand treats Him like a pimp daddy: *do this and that for me, but I will not commit to you.* God cannot trust that type of person, and the greater revelation will not come. Unless you change your ways and follow Him wholeheartedly, it will be difficult to hear His voice.

We need to seek God deeply, not in a shallow way. God likes when we take time to thank Him for doing or revealing something. We need to be appreciative. Do you want God to do great things for you? Thank Him every day. Show Him how much you appreciate all He has done for you since you were a little baby. He always has you in mind. He truly loves you.

Think about this for a moment: your son or daughter tells you, "You are the best daddy or mommy in the whole world. Thank you for taking care of me, for feeding and clothing me when I was unable to do it myself."

What would your response be? You probably would be amazed and happy and, frankly, it would make you want to do more for that child. God feels the same way when we are genuinely appreciative. He wants to do more for us. Learn to appreciate all that God has done and will do for you in the future. Be thankful in advance. Your relationship with God will improve greatly.

Chapter 6

His Voice Becomes Familiar to You

The more time you spend with God, the more familiar His voice will become. "And a stranger voice they will not follow but they will flee from him: for they know not the voice of stranger" (John 10:5 NKJV). We must realize how important it is to spend quality time with God. He does not want us to work and work and not have time to be intimate with Him. The more time we spend in fellowship with Him, the more we likely we are to know His voice.

I was born outside a small Haitian town called Trou-Du-Nord, which means "through the north." I lived there with my praying grandmother until I was four years old and then moved to the United States to live with my unsaved mother. As far as I am aware, my grandmother was the only person in my family who was saved.

She had many grandchildren. When all her grandchildren gathered to play at her house, we made some serious noise.

Even though I was only four years old, she could recognize my voice among all the others. She would immediately call to me to stop the noise. She was loving but firm. I occasionally got a good spanking. She often told me, "You are called." I did not know what that meant then, but I do today.

God wants us to recognize His voice. The only way we will know Him is if we spend a lot of time with Him. His actions prove that He loves us, and so He desires our attention. We need to give Him the attention He craves and truly deserves. When we spend our time doing things rather than spending time with Him, He gets jealous. "For I am the Lord. Your God is a jealous God" (Exodus 20:5 NKJV). He does not want us to do our own thing unless He is involved.

In the early part of my ministry (Worldwide Agape Ministry) I worked with a group of young people. Many of their lives had changed for the better, but some still struggled just as many adults do. One young man in particular made a statement that caught my attention. He said, "Well, Pastor, I know that God has a plan for me and even speaks to me sometimes. But I want to have my own plan and do my own thing." I knew he was heading in the wrong direction.

Unfortunately, that is how many Christians behave. We must be about His plan and His purpose. This young man's life spiraled down the drain. He was deported to the Bahamas because he was dealing in contraband. That was the last story that I heard about him. The Word had been preached to him; perhaps it will take root while he is in prison.

Sometimes it may seem that everything is turning against you. But all God is trying to do is to draw you back to Him. He has been trying to get your attention, and you are not listening. He takes you to a place where you might listen to Him.

We need to learn to recognize God's voice and follow His plan for us. As men and women of God, we need to listen to His voice and follow His instructions, which He issues every day. We must not have the attitude of that young man I described earlier.

> When you pass through the waters, I will be with you; and through the rivers, they shall not overflow you, and when you walk through the fire, you shall not be burn; neither shall the flame kindle upon you.
>
> For I am the Lord your God, the Holy One of Israel, your Savior: I gave Egypt for you're as a ransom, Ethiopia, and Seba for you.
>
> Since you were precious in my sight, you have been honorable and I have loved you: therefore I will give men for you, and people for your life. (Isaiah 43:2–4 NKJV)

In this biblical passage, God says that He loves us so much He'll pay nations as a ransom on our behalf. What does He require from us in return? Hear Him out, and listen and follow. What a good God! Yet many of us want to do our own thing. We wonder why our prayers do not get an

answer. Why don't we get the breaks we deserve? Why aren't we healed, even though we pray over and over?

We need to check on how we behave toward God. We need to draw near to Him, to become familiar with Him, to obey His voice. The truth is He loves you and me. There is nothing that will ever change that. He is the ultimate God. The lover-in-chief is in love with us. He truly loves us. We must learn how to listen to Him.

What Is He Looking For?

God is looking for fellowship with His own creation. The scriptures tell us that Adam and Eve used to fellowship with God in the garden, until they sinned and noticed that they were naked: "And they heard the voice of the Lord God walking in the garden in the cool of the day: and Adam and his wife hid themselves from the presence of the Lord God amongst the tree of the garden" (Genesis 3:8 KJV).

You see, my brothers and sisters, God is looking for fellowship with us. He wants us even more than we realize. He loves it when we talk to Him. Instead of giving Him a great list of everything we want Him to do for us, let us love Him first, and then ask Him. Worship Him, and let Him know how important He is to you. Of course, He already knows that, but it's good to hear it from His children.

What separates us from the love of God? According to Romans 8:38–39 (NIV), "neither death nor life, neither angel or demons, neither the present nor the future, nor any powers, neither height nor depth, nor anything else in

all creation, will be able to separate us from the love of God that is in Christ Jesus our Lord."

Since nothing can separate us from the love of God, we should recognize and know His voice. We should be familiar with His ways of doing things. When you know someone, you know what that person is capable of. We must get to the point where we know God's voice, His character, His abilities, His dos and don'ts.

"But seek first the kingdom of God and His righteousness and all these things shall be added to you" (Matthew 6:33 NKJV). We must seek God's kingdom and God's righteous way of doing things. When we follow God, we will always be successful.

Chapter 7

God Speaks to Us through Visions and Dreams

God clearly uses visions and dreams to speak to us. There are many examples in the Bible. Again, we ask the question: For what purpose? He is God. No one can vote Him in, and no one can vote Him out.

This example is one of my favorites:

> In the second year of his reign, Nebuchadnezzar had dreams; his mind was troubled and he could not sleep. So the king summoned the magicians, enchanters, sorcerers, and astrologers to tell him what he had dreams. When they came and stood before the king, He said to them, "I have had dreams that trouble me, and I want to know what it means." (Daniel 2:1–3 NIV)

No one in the king's circle was able to interpret his dreams. He was absolutely furious. Then the man of God—Daniel, who clearly could hear and obey the voice of God—came on scene. It was not Daniel's choice to be there; however, God was going to get the glory and the honor. God was going to use His vessels to make a point. He will use us to make a point, because we are His workmanship. We work for Him and in conjunction with Him.

During the night, God revealed the meaning of the dream to Daniel (2:19 NKJV). You know the rest of the story; Daniel and his boys—Shadrach, Meshach, and Abednego—were promoted, and God got the glory. Glory be to God.

What caused the answer to come? Daniel and his boys sought the Lord on behalf of the whole nation. One man who is that hungry for God can make a big difference. Daniel did not care that he was in foreign land; he did not have any excuses, and he did not worry about the obstacles. He sought the Lord, and the Lord gave him the answer. Listen to what God said about Daniel and his three friends: "As for these four young men, God gave them knowledge and skill and literature and wisdom; and Daniel had understanding in all vision and dreams" (Daniel 1:17 NKJV).

We need to put Him first in all that we do. The victory will come much sooner and smoother. Instead of trying to figure it out on our own and getting lost, we should involve God at the beginning of every project. He will make sure that we have the best results.

Daniel realized that he was part of the Lord's plan and began to praise God:

> Blessed be the name of God forever and ever, for wisdom and might are His.
>
> And He changes time and seasons; He removes kings and raises up kings; He gives wisdom to wise
>
> And knowledge to those who have understanding.
>
> He reveals deep and secret things; He knows what is in the darkness, and light dwells within Him.
>
> "I thank You and praise You, O God of my father; You have given me wisdom and might, and have now made known to me what we have ask of You. For you have made known to us the king's demand." (Daniel 2:20–23 NKJV)

Daniel truly had great understanding of who God was in his life. He heard and obeyed God's command and as a result became successful. He was promoted because of his relationship with God.

The other example I admire is the Macedonian call described in Acts 16:6–10 (NKJV):

> Now when they had gone through Phrygia and the region of Galatia, they were forbidden by the Holy Spirit to preach the word in Asia. After they had come to Mysia, they tried to go into Bithynia, but the Spirit did not permit them. So passing by Mysia, they came down to Troas. And a vision appeared to Paul in the night. A man of Macedonia stood and pleaded with him, saying, "Come over to Macedonia and help us." Now after he had seen the vision, immediately we sought to go to Macedonia, concluding that the Lord had called us to preach the gospel to them.

These two examples show that God uses dreams and visions to get His message to us. What we, as His sons and daughters, have to do is to keep asking Him to use us in the way that is best for His glory. He'll use you and me in whatever way He wants to, but we have to be open vessels. We are His workmanship. Be ready to be used by Him—whenever, wherever, however.

Chapter 8

He Can Speak to You through His Word

One of the most accurate ways God speaks to us is through His Word. Why? His Word has been tested. His Word will never lie. His Word is the truth. Jesus said, "The words that I speak to you are spirit, and they are life" (John 6:63 KJV). If God speaks to you, He will confirm His Word, which will always come to pass.

How does one differentiate between the different ways of speaking—God's way, your way, and the devil's way? There is a very simple answer:

1. Your way will be characterized by self-promotion and self-interest. Your way will be self-centered and self-focused.
2. The devil's way will be driven by the enemy, of course. It will encourage you to steal, kill, and destroy. John 10:10 (NKJV) says, "The thief does not come except to steal, and to kill, and to destroy.

I have come that they may have life, and that they may have it more abundantly." The Amplified Bible version says, "I came that they may have and enjoy life, and have it in abundance (to the full, till it overflows)."

3. God's way is to edify, exhort, comfort, or promote, and sometimes to warn. For example, if you hear this statement in your spirit, "You did not read your Bible today," who said that? The answer will be confirmed by His Word.

Let us examine the situation. You have to know that thought did not come from your natural, carnal mind. According to Romans 8:7 (AMP), "[That is] because the mind of the flesh [with its carnal thoughts and purposes] is hostile to God, for it does not submit itself to God's law; indeed it cannot." The New International Version says, "The mind governed by the flesh is hostile to God; it does not submit to God's law, nor can it do so."

The carnal mind is hostile to God's Word or law. You know the devil will not encourage you to read the Bible. He will discourage you and tell you all kinds of nonsensical lies. The devil is a big liar. He is the father of all lies.

The statement was spoken by your spirit man, and the message came from God, who wants to make sure you are acquainted with His Word. You should not be confused about whom is saying what to you. The more you read and meditate on His Word, the more God will speak to you through it. As believers, we need to know what He is saying to us about every subject.

God always has something to say about everything that we are going through. We should consult Him before we make any decision about our lives or any other issues. He should always be our first consultant. If the solution does not line up with His Word, chances are it will not work for you because it is not His will.

For example, you meet a good-looking man. He sweeps you off your feet, and you date him. He is not a believer; he has nothing to do with God. But you fall deeply in love with him. He asks you to marry him. You pray about it, and God says, "No, he is not the one."

You have a physical relationship with this man; therefore, it's hard for you to detach. You ask a person with godly wisdom for advice, who says your relationship is not the will of God. You are in love; you dismiss all the warnings that have been given to you. You marry the man. Two weeks after the wedding you find out that Mr. Charming is the devil himself. He's given you an STD. Now you are now mad at God. You ask God, "Why did You let this thing happen to me?"

It is not God's fault. It is your fault.

Find out what His Word says, and base your decision on that. It is His Word that makes the difference, nothing else.

> As the heavens are higher than the earth,
> so are my ways higher than your ways
> and my thoughts than your thoughts.

As the rain and snow come
down from heaven,
and do not return to it without
watering the earth
and making it bud and flourish,
so that it yields seed to the sower
and bread for the eater,
so is my word that goes
out from my mouth:
it will not return to me empty or void
but it will accomplish what I desire
and achieve the purpose for which I sent it.
(Isaiah 55:9–11 NIV)

We know from the scriptures that God speaks to us and through us, exactly in line with His Word. Whatever He says will come to pass. Sometimes it tarries, but eventually it will come to pass. Be ready to do whatever He asks you to do.

Chapter 9

Recognize His Voice and His Purpose for You

God doesn't talk just to hear His own voice. He always has a reason for doing a certain thing. Not everyone will know what He is doing; however, He will reveal Himself to certain people. "Surely Lord God will do nothing without revealing His secrets to His servants the prophets" (Amos 3:7 AMP).

He will reveal Himself to certain individuals, if they are listening to Him. A large percentage of believers don't know if God still speaks today. They make such statements as, "Brother, I am a strong believer of the Bible. I believe it from Genesis to Revelation." Yes, my brothers and sisters, that may be true, but that's not enough.

We must get to the point where we study the Bible and know God's plans and purpose for our lives. We must hear His voice. What I mean is this: we must take time to

1. *meditate* on His Word;
2. *confess* His Word;
3. *pray* His Word;
4. *sing* His Word; and
5. *act* on His Word.

Then we will see His Word manifested in our lives. We will see the results of the Word come to pass. As I mentioned above, God has a plan for all our lives. We have to find it and, once we do, we have to go full speed ahead.

The days of just listening to the preacher on Sunday morning are over. We must open the Bible for ourselves and practice what the Word of God says. Get that Bible, and crack it open. See what God has to say. Get to know His voice. Become accustomed to listening to Him, and act on His plan.

Chapter 10

Come into Agreement with His Word

We must be an agreement with His Word. "Can two walk together, except they be agreed?" (Amos 3:3 KJV). Yes, it is important to be an agreement with God's Word, because then it is easier to hear Him. Let us live God's Word. Let us move forward, and march like the strong army we are.

God is calling for some great soldiers who are willing to give up everything to go on this great journey. He is also looking for soldiers who can hear His voice and be obedient for the great work that is at hand. He is calling for soldiers like you and me. We have to step up to the plate and march toward the next great task He has for us: "Again I say to you that if two of you agree on earth concerning anything that they ask, it will be done for them by my Father in heaven." (Matthew 18:19 NKJV).

When we are in agreement with God's Word, His Word will come to pass. When we hear His voice, we must agree, because what He says will come to pass.

Here is one example: several years ago I purchased a brand new red Jeep Cherokee for only $100. How did that happen? My wife and I had been praying for a vehicle. We did not have a car at that time. After we prayed, my wife caught the bus and went to work. There was a grocery store nearby. My wife heard the voice of God, who told her to "go to the grocery store and pick out a car magazine." She was obedient and listened to the voice of God. On her way to work, she went to the store and picked up the magazine. She saw an almost-new red Jeep Cherokee on the cover. She heard the voice again: "This is the car I want you and your husband to have." She knew immediately that it was the voice of God. She told me what had happened. We were in agreement, about this matter anyway.

Although we had not prayed for a specific car, we did want something new. We also knew that if two people agree about anything they ask the Father, it shall be given to them: "Therefore I say unto you, What things so ever you desire, when you pray, believe that you receive them and you shall have them" (Mark 11:24 KJV). Those were the words on which we depended. We confessed those words all the time.

We agreed with God's Word. The car was at the dealership. I went there that same day. I had opportunity to see many cars, but I was not interested in others. I wanted the car the Holy Spirit had shown my wife. After the salesman showed me all other cars, I asked him, "Do you have a red

Jeep Cherokee?" He hesitated and said no. I asked again, "Are you sure you don't have a red Jeep Cherokee?" I knew that the Holy Spirit wouldn't lie. The scriptures tell us to let every man be a liar, but the Word of God is the truth.

The salesman seemed confused, and he hesitated. He told me to hold on, and he went to check in the back. He came back with a smile on his face and said, "I saw the red Jeep parking in the back of the dealership." I went to look, and when I saw it, my heart leapt. I knew immediately that was my vehicle. I didn't have any money on me, but I had God's confirmation.

When God makes a promise, rest assured; He will take care of everything. You don't have to worry if you don't have the money, because if it's His vision, He'll bring the provision. The enemy will try to make you think you won't get what God promises. If God promised it, it will come to pass.

Once I saw the car, I knew for sure that it was mine. I was thinking, *Where will the money come from?* But I knew I could not let the enemy steal my blessing. I thanked Him for the car and the money. God spoke to me again. He said, "Tell him you have to go home to get the money." The salesman asked me about the money. I told him my father had it, that I needed to go home and get it. I spoke the language of faith because I did not have the cash on me.

I called my wife and asked if she had any money in the house. She told me she had only $100, which she needed to pay a light bill. I told the man I had $100 at the house. He said okay. I was shocked and amazed.

"I will fill out all the paperwork," the salesman said, "and you can take the car. Bring the $100 back to me, and pay the rest when you can." The car's retail price was between $18,000 and $20,000.

I praised God all the way home. I thought I had to be dreaming. Eventually we paid for the car in full. God is good. We must heed His written Word and His spoken word.

God does not respect the person, but He honors His people's faith. Jesus said to have faith in God or have God's kind of faith (Mark 11:22). When you are in agreement with His Word, you can rob the windows of heaven. Whatever you ask for, you shall have. Why are you seeking God? Why do you believe in God?

"But without faith it is impossible to please him: for he that cometh to God must believe that he is, and that he is a rewarder of them that diligently seek Him" (Hebrews 11:6 KJV). Can you seek God without any reservation? Can you seek Him with everything you've got? He is waiting on us to believe in Him fully and put all our trust in Him.

We should listen to His voice, be in agreement with Him, and do what He asks us to do. Stay in accord with Him. He will see us through every time. Yes, He is waiting for us to take a leap of faith. Let's put our trust in Him. He will see us through.

Chapter 11

Confess: God Speaks to You Every Day

Expect God to speak to you on a daily basis, and then confess it. It will happen. Expect something good to happen today. Expect God's favor and prosperity on a regular basis. Refuse anything that discourages you or leads to sickness and disease. Take charge of the situation by believing that God speaks to you about favor, success, or whatever else He desires. God wants to speak to you as much as you desire to speak to Him.

Expect God to speak to you about His purpose and plan for your life. Confess it on a daily basis. If you don't know what the will of God is, confess the following daily until it comes to pass: "God's has a plan and purpose for my life." The next thing you know, you will be operating in God's perfect plan.

For example, God told me to confess, "I have the superabundant power of God working in me. His will is that I go far beyond my highest expectations, thoughts,

hopes, and dreams. His perfect will is being done in me."
I have confessed this daily ever since. The results manifest
daily in my life, which has been—and is still—changing
every day. I would encourage you to confess as many times
as is necessary to see tangible changes in your life.

You should also confess on a daily basis God's perfect will for
your family, His church, your church, your pastor. Perhaps,
you say, "I don't have a pastor." Everyone needs a pastor.
Even Jesus had a pastor—John the Baptist. If you don't have
one yet, ask the Holy Spirit, "Who is my pastor?" He will
lead you to your pastor, your shepherd. It is just that simple.

The more you declare that God's Word rules over your life,
the easier it will be for Him to speak to you. Declare this
over your life:

> Whatever the Word of God says I am, I am.
> I am a new creation created in Christ Jesus.
> I am the righteousness of God in Christ. I
> hear His voice, I hear the voice of the Good
> Shepherd and the voice of a stranger, and
> I shall not follow the latter. I hearken unto
> the voice of the Lord.
>
> I walk in the blessings of Abraham, Isaac,
> and Jacob. The blessings of the Lord make
> me rich, and He adds no sorrow to my life.
> God works in me. I obey my Father's voice,
> which is like streams of water (Psalm 1:3).
> His voice brings me comfort, strength, and
> edification. He is the head, not the tail. He

makes me the lender, not the borrower, and
puts me on the top, never at the bottom. He
is my daddy. I am healed, delivered, and set
free in Jesus's name. Amen.

God desires to do great things in our lives. He wants to see
us fulfill His plan for our lives. He will not keep anything
from us that will advance our lives. "No good thing does
He withhold from those who walk uprightly" (Psalm 84:11
NASB). You see, my beloved brothers and sisters, you must
confess God's Word on a daily basis and walk uprightly with
Him. You will see the changes. You will hear His voice.

About the Author

Ernest Murat has a master's degree in Christian counseling and a doctorate in divinity. He is the founder and pastor of Worldwide Agape Ministries. He also served in the mission field in many countries, including Haiti, Dominican Republic, and Costa Rica. He has been married to Jeanne Murat for twenty-three years. He has no children in the natural but too many to count in the mission field.

Printed in the United States
By Bookmasters